CUTE LITTLE THINGS
24 PAGE COLORING BOOK

Illustrated by Dani Kates

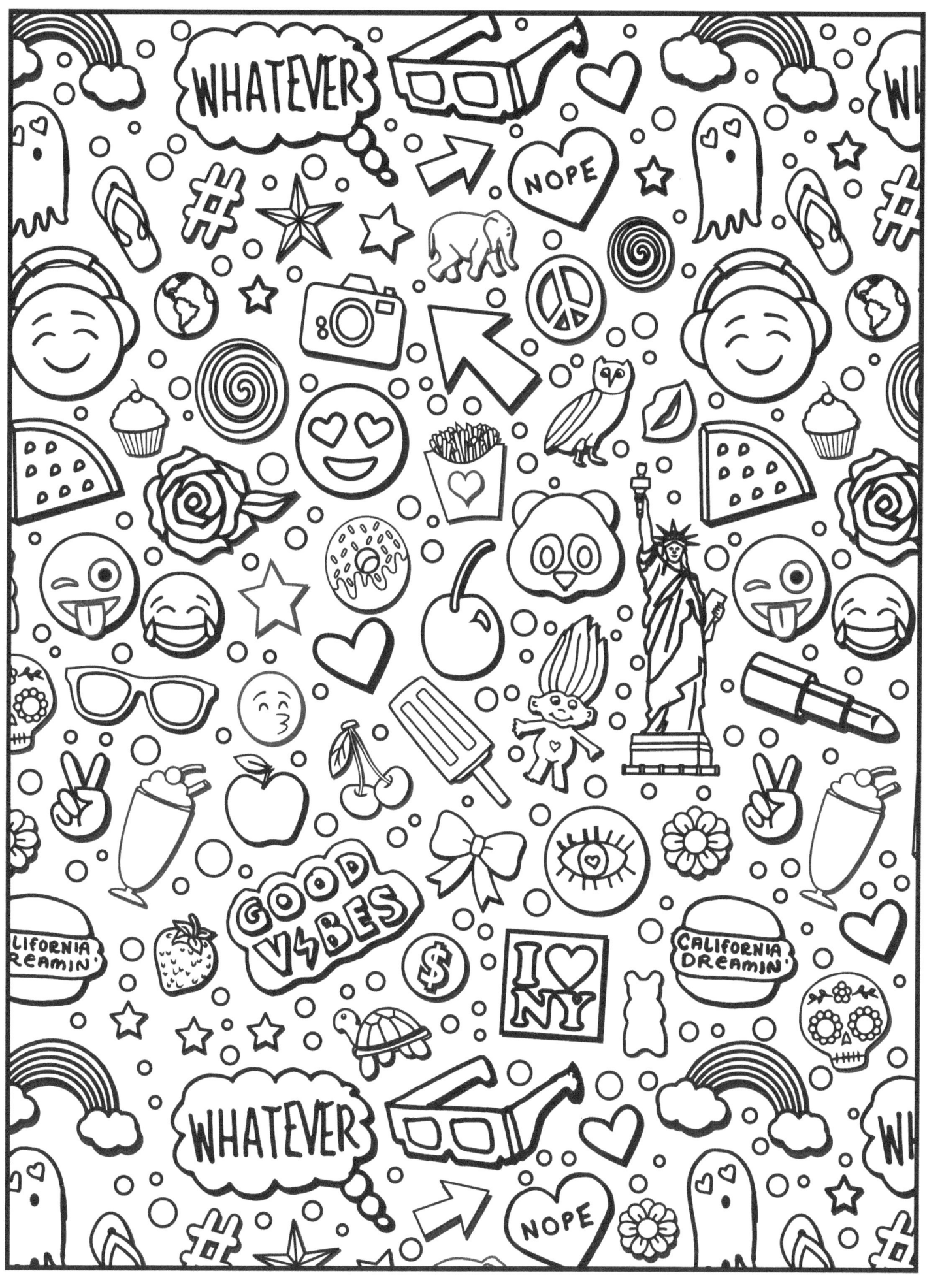

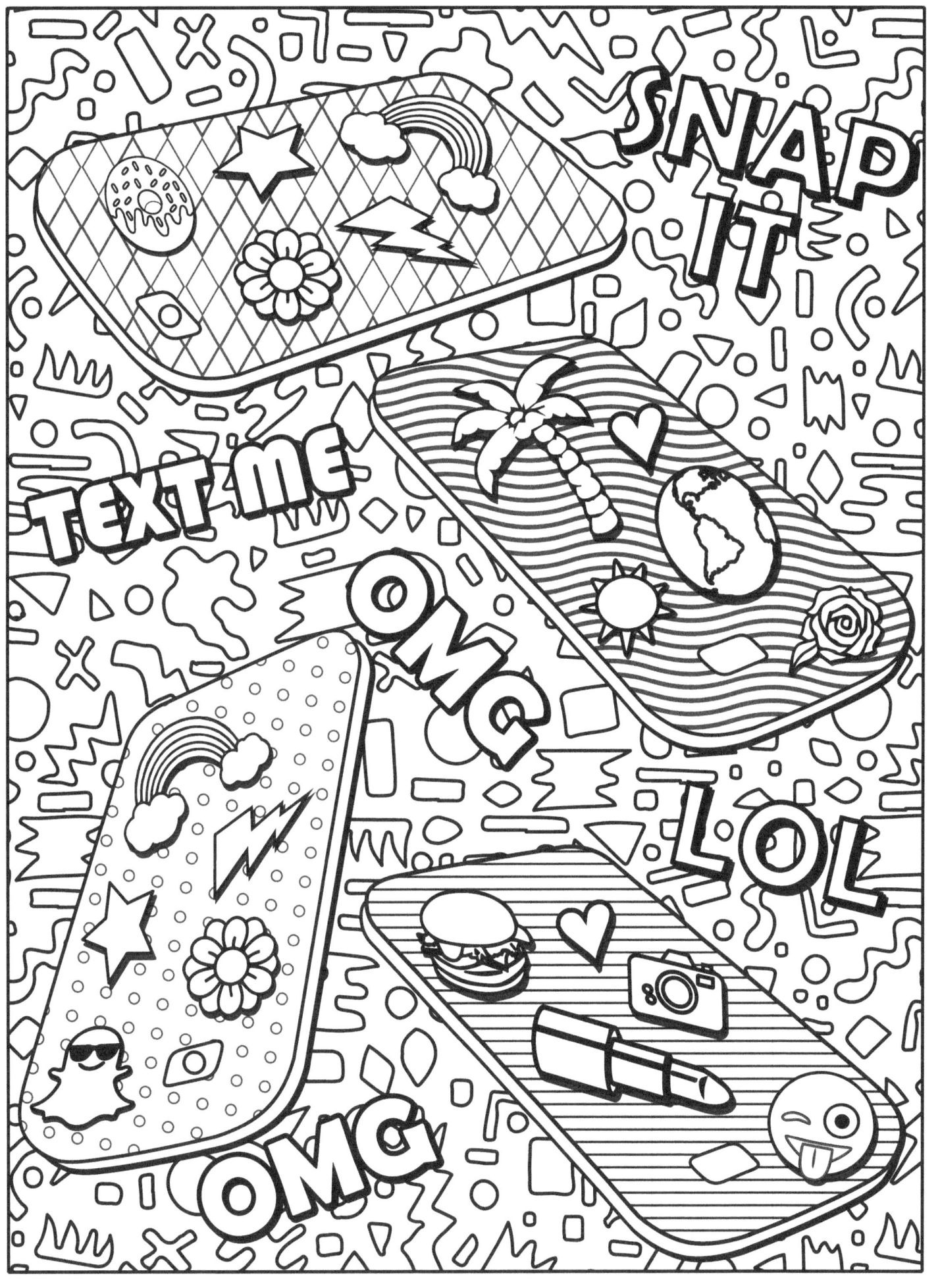

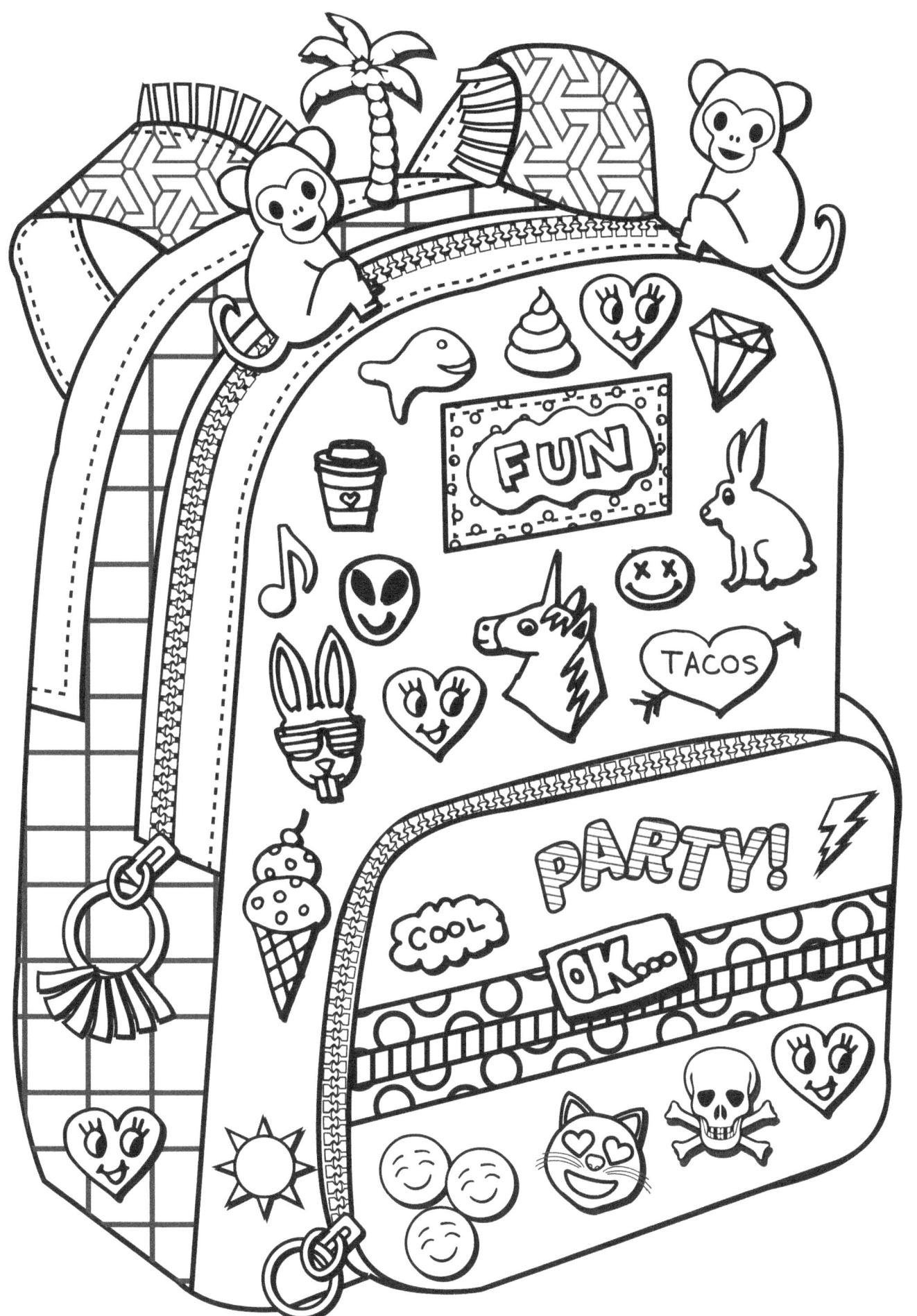

DESSERT MENU

CAKES

ICE CREAM

CUPCAKES

DONUTS

| STRAWBERRY | CHOCOLATE | VANILLA | MINT | CHERRY | TUTTI FRUITI RAINBOW |

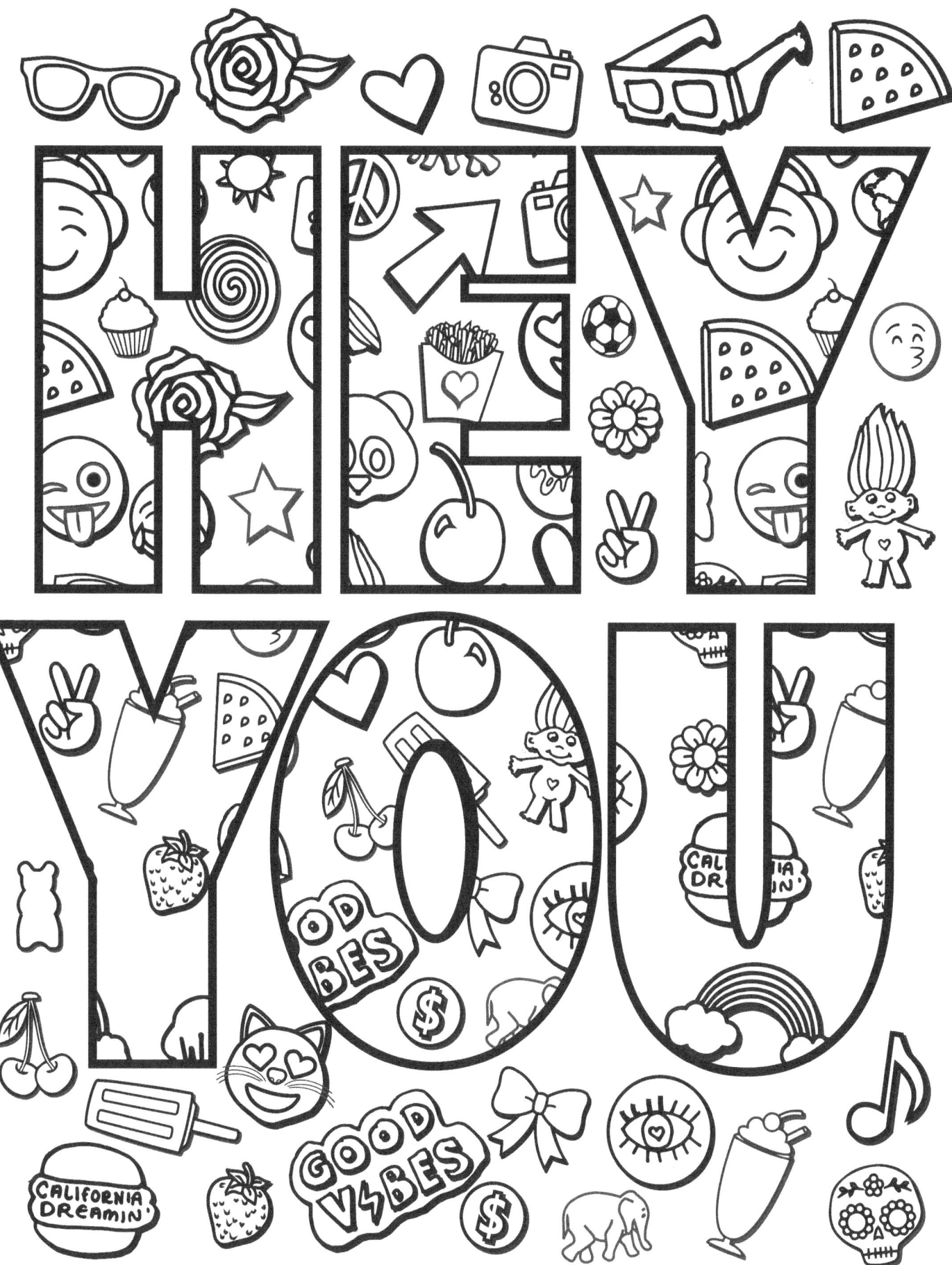

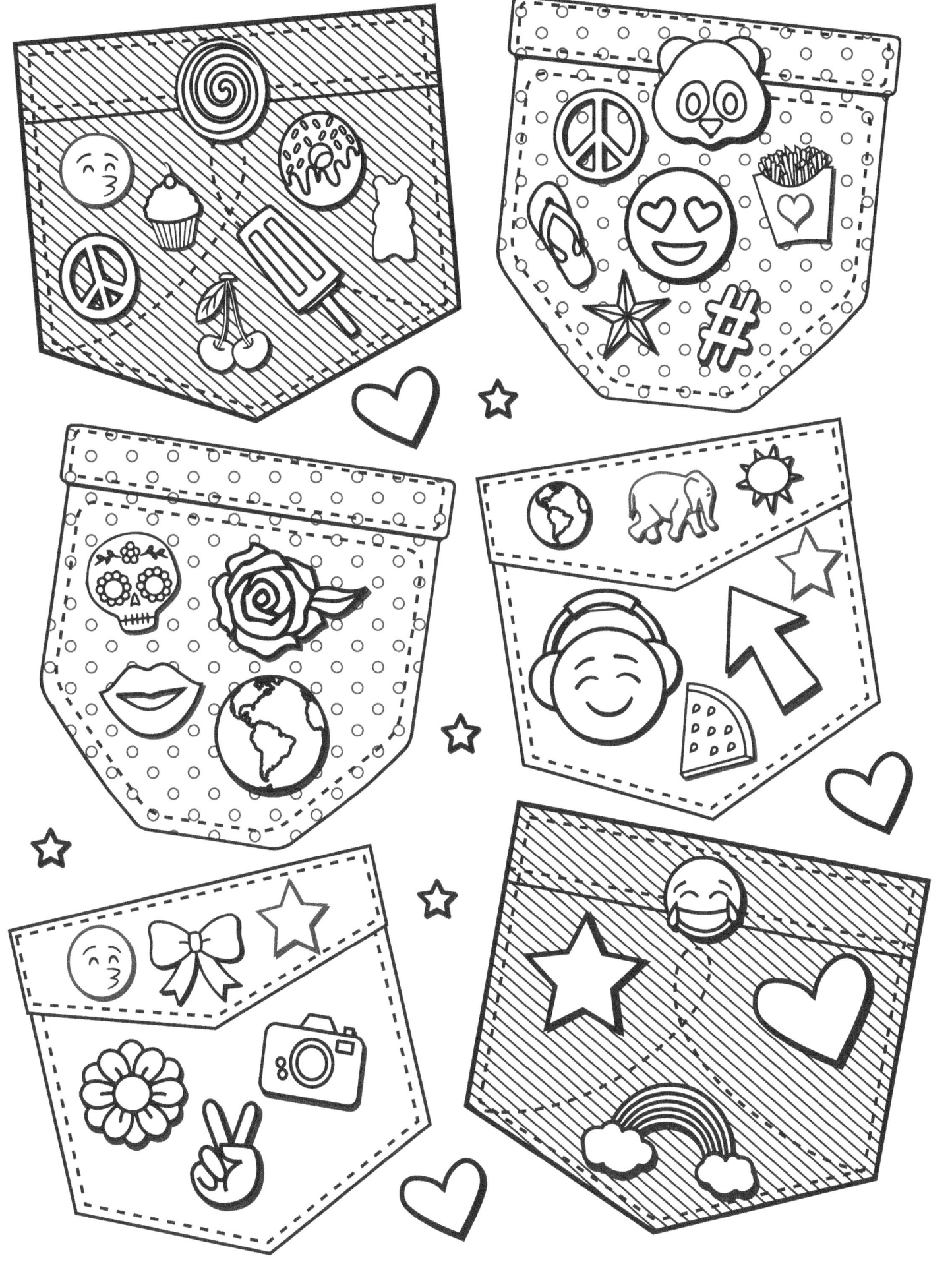

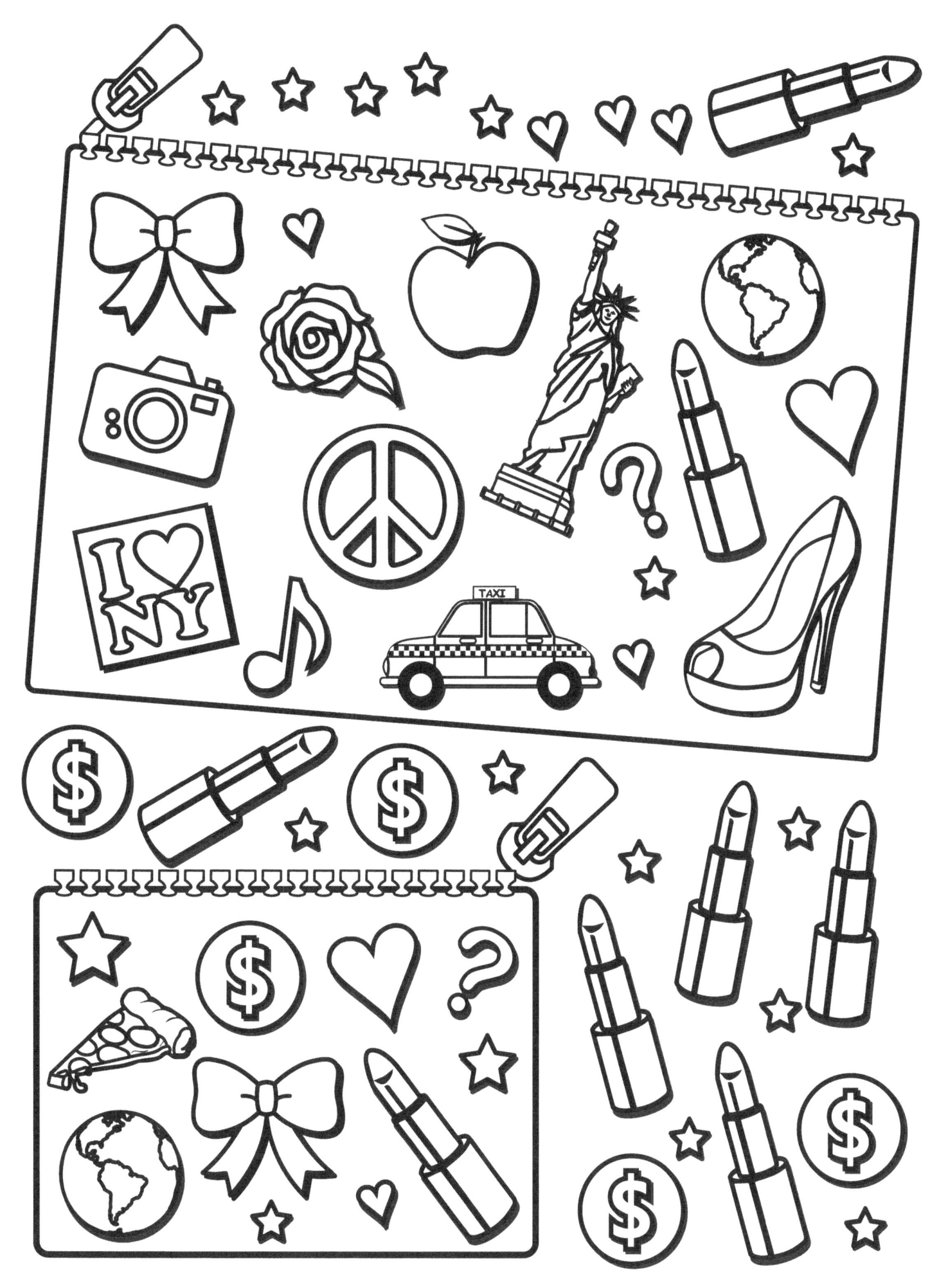

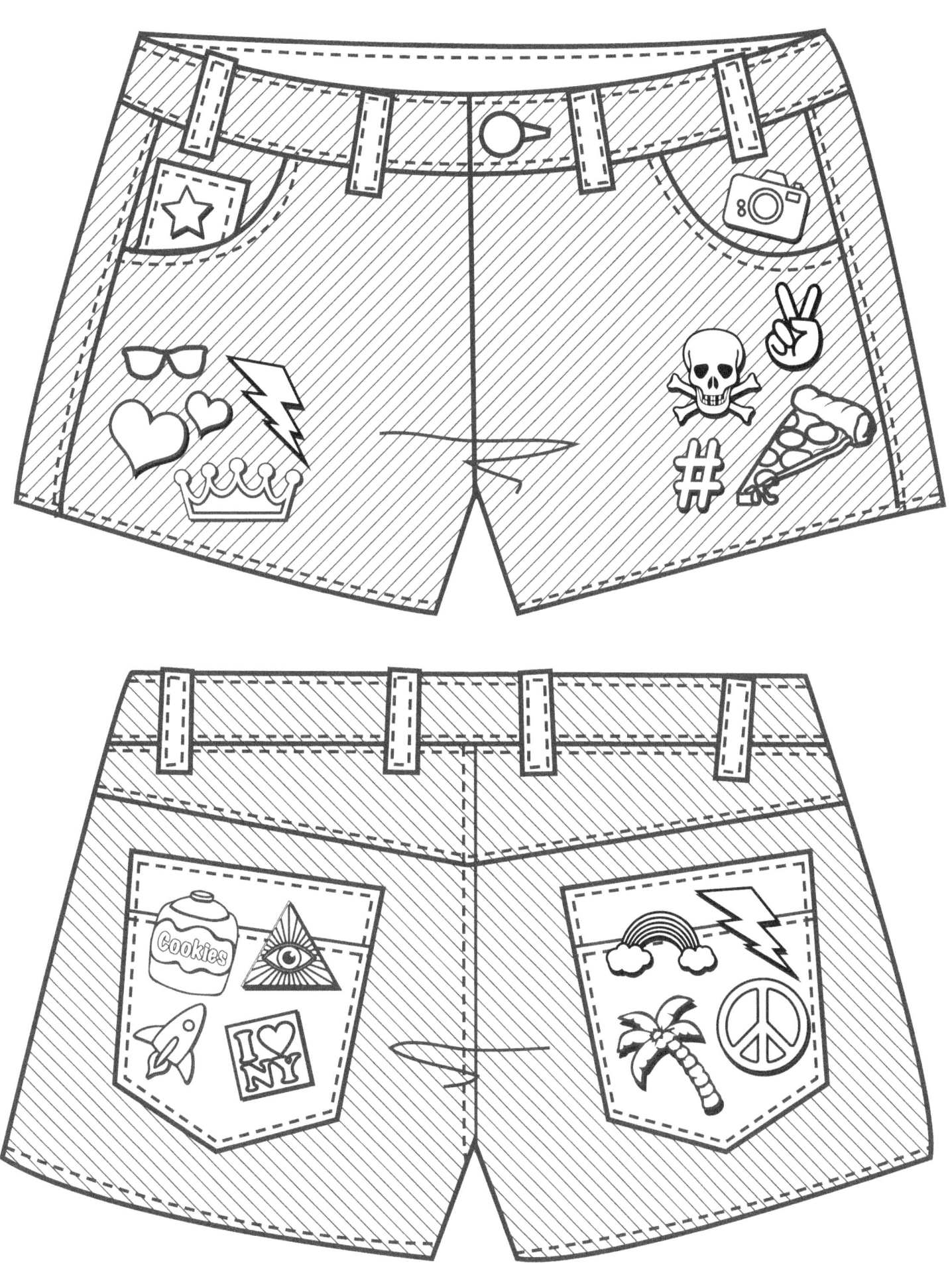

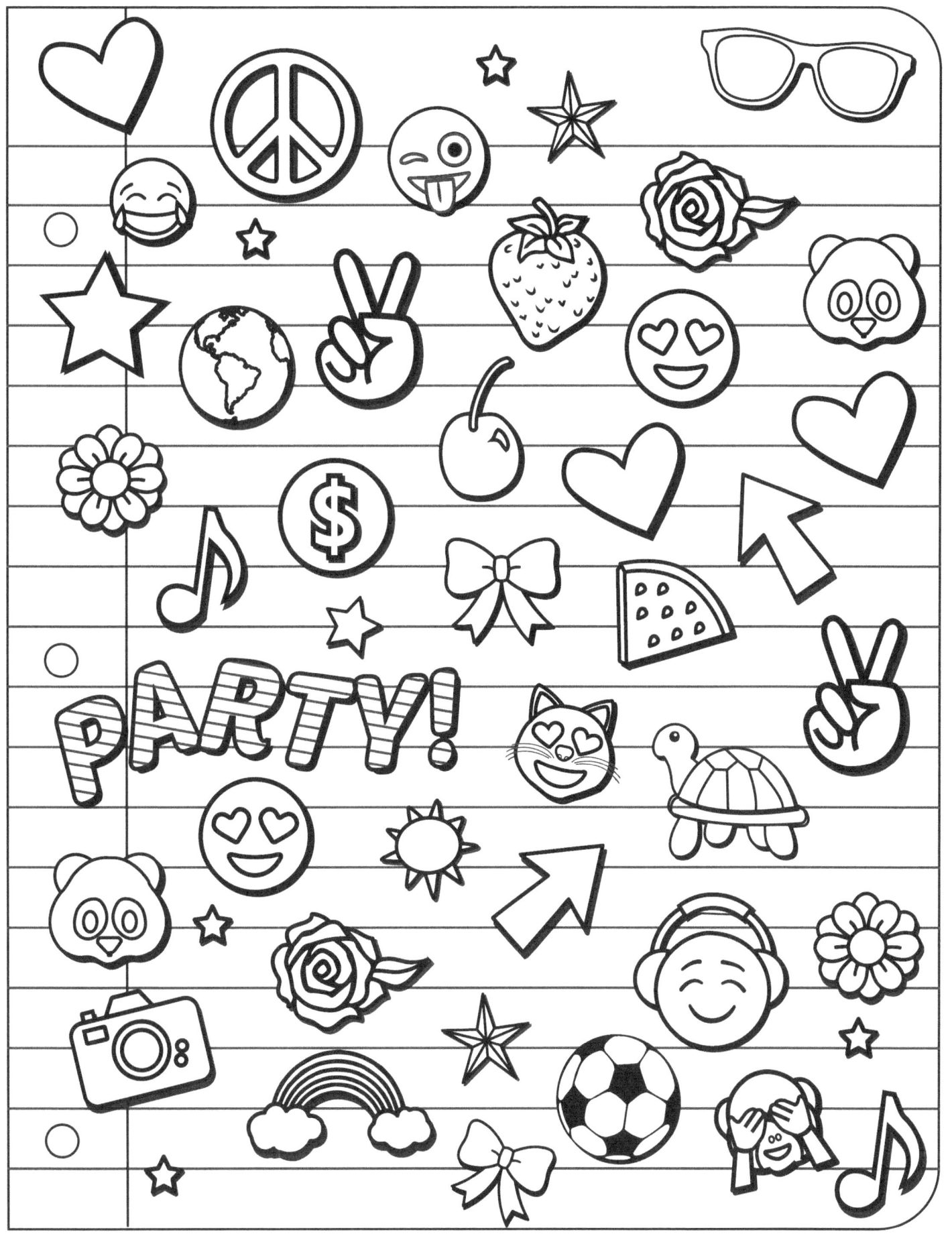

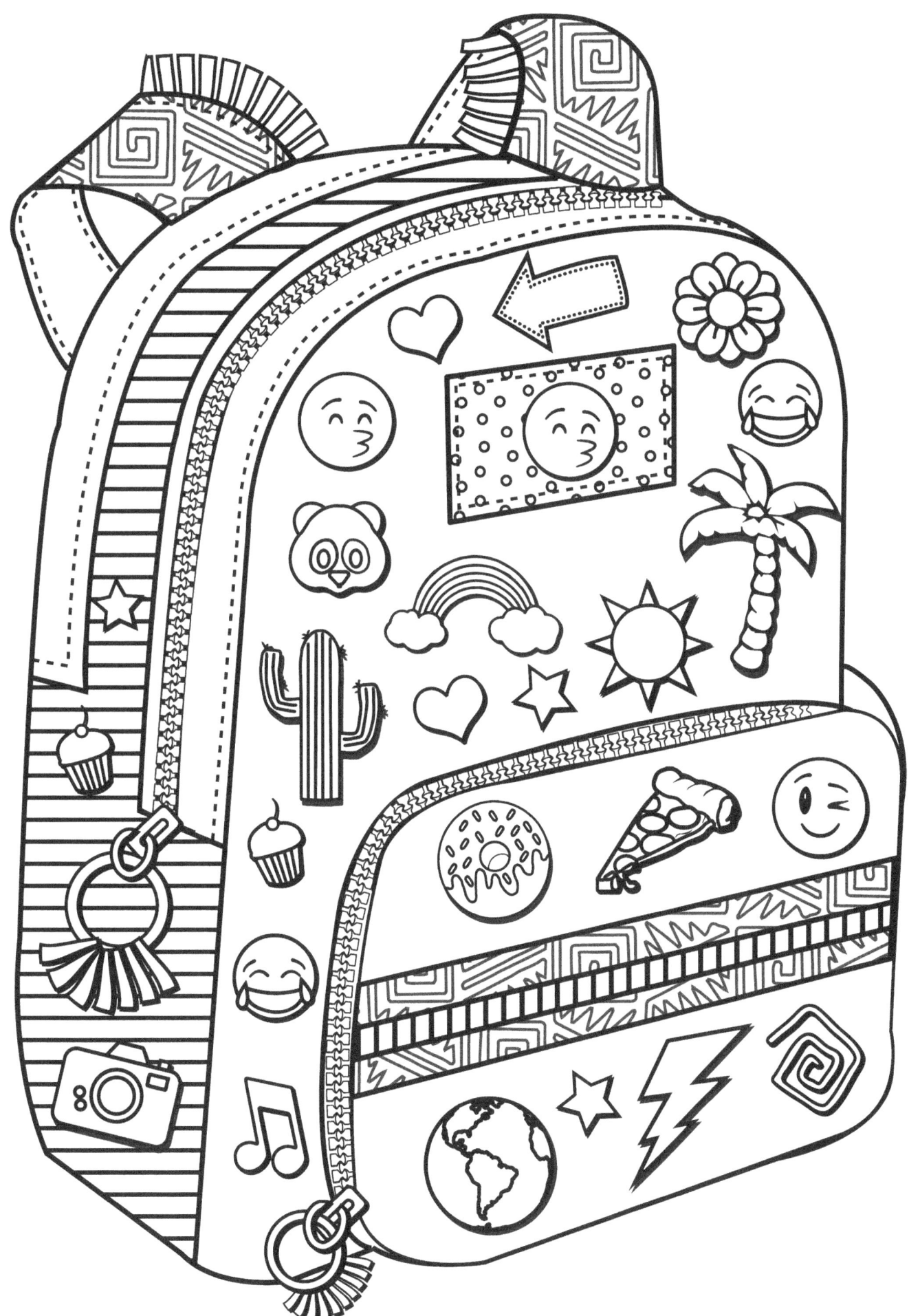

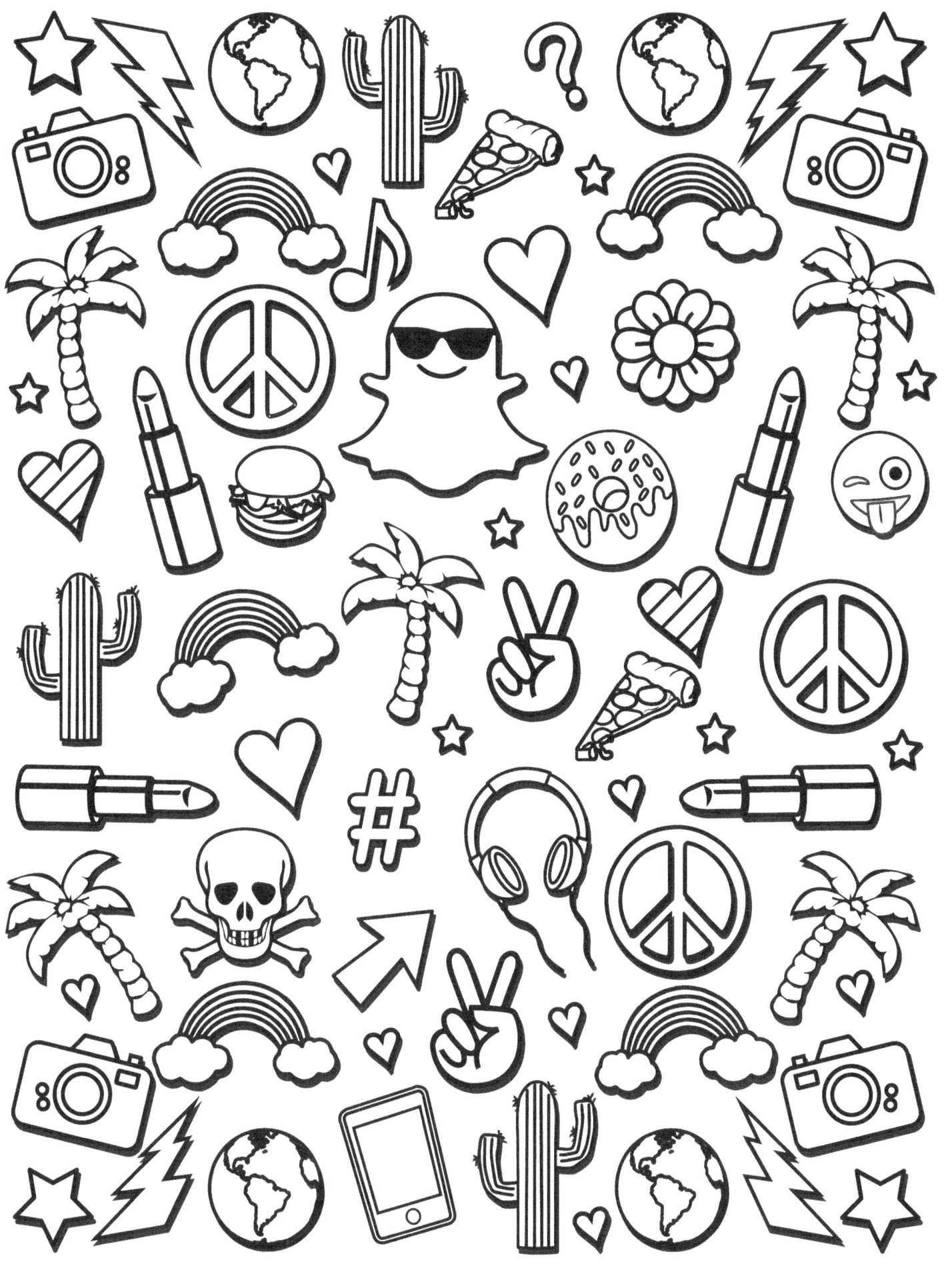

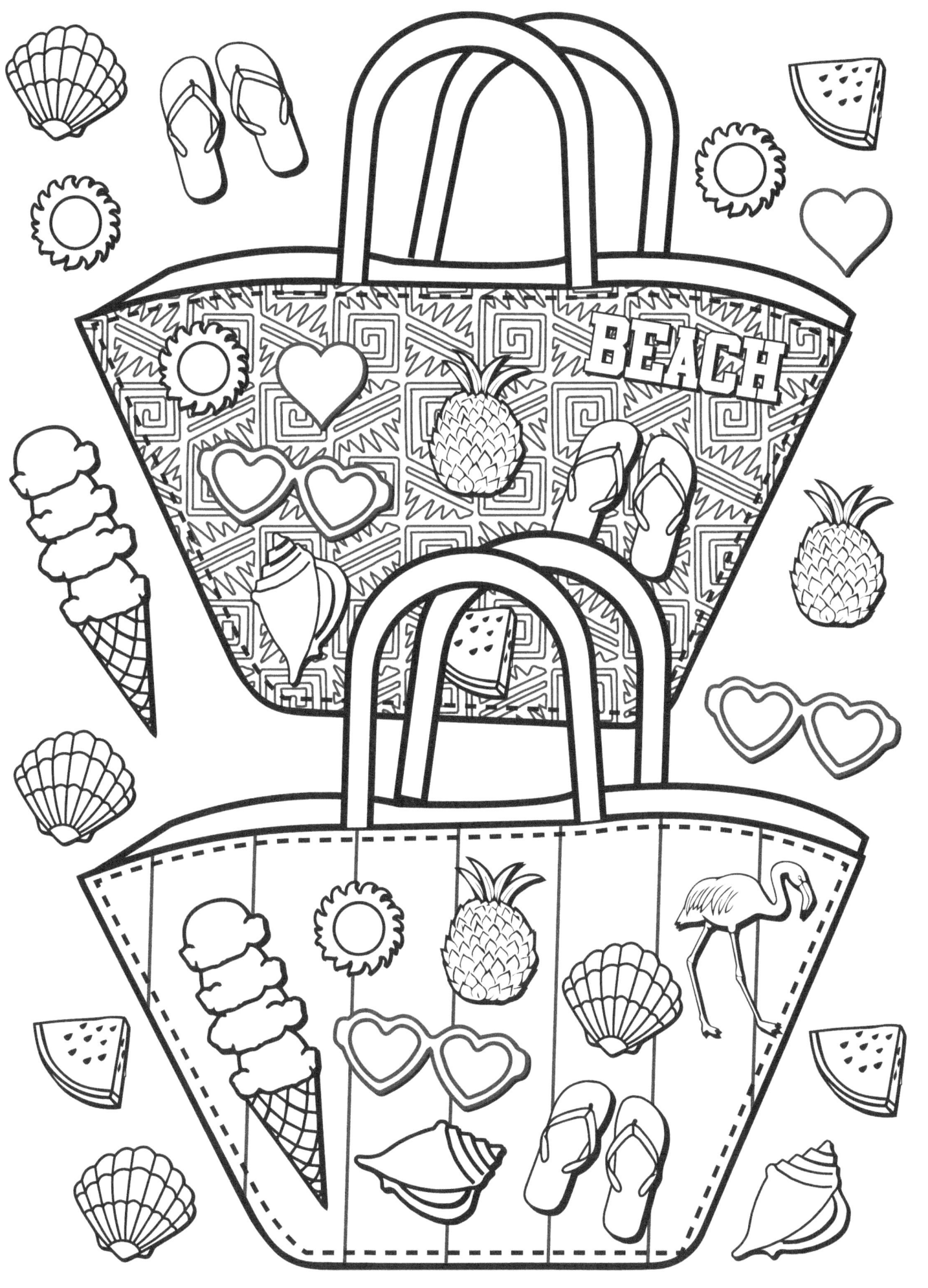

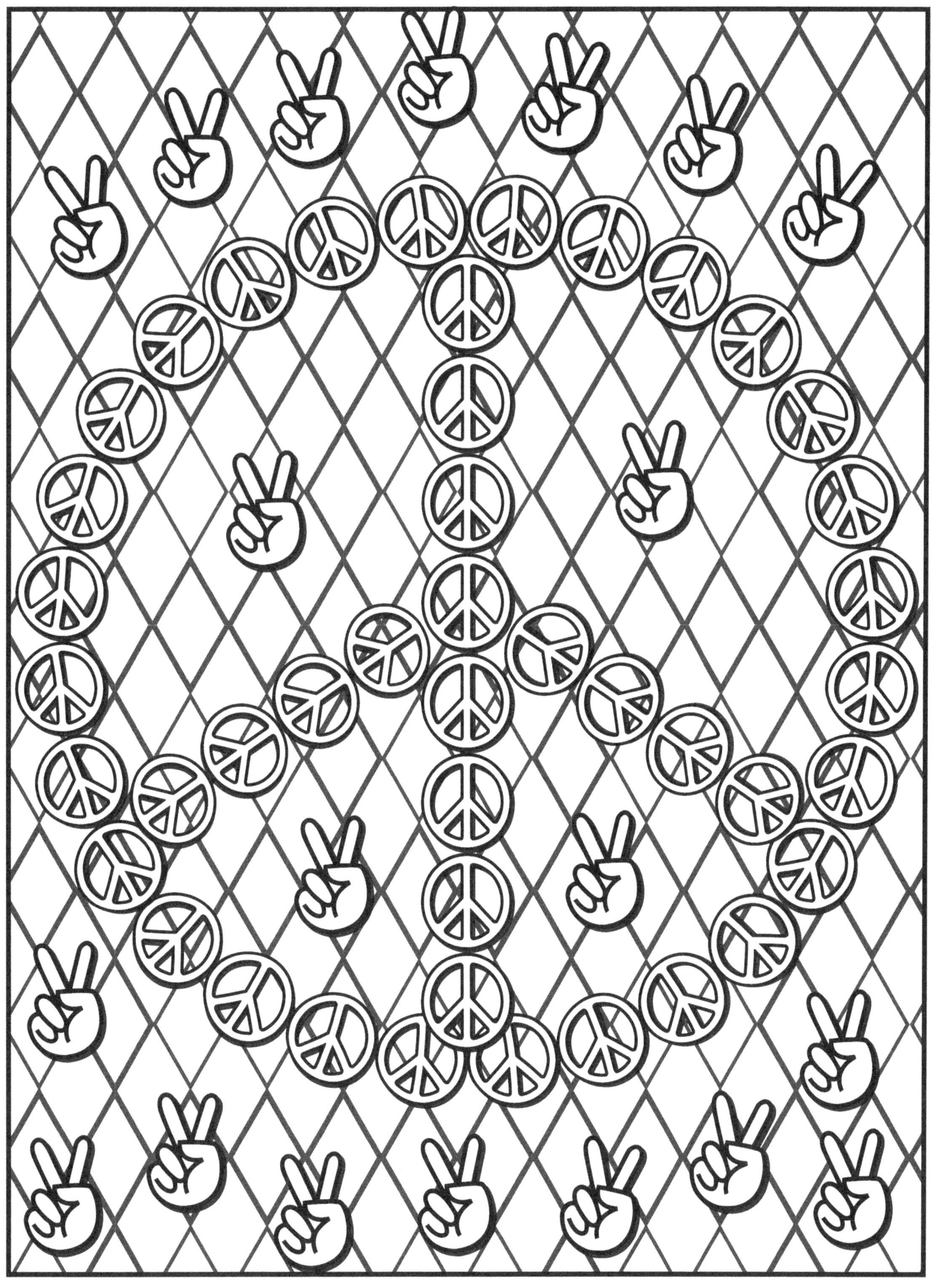

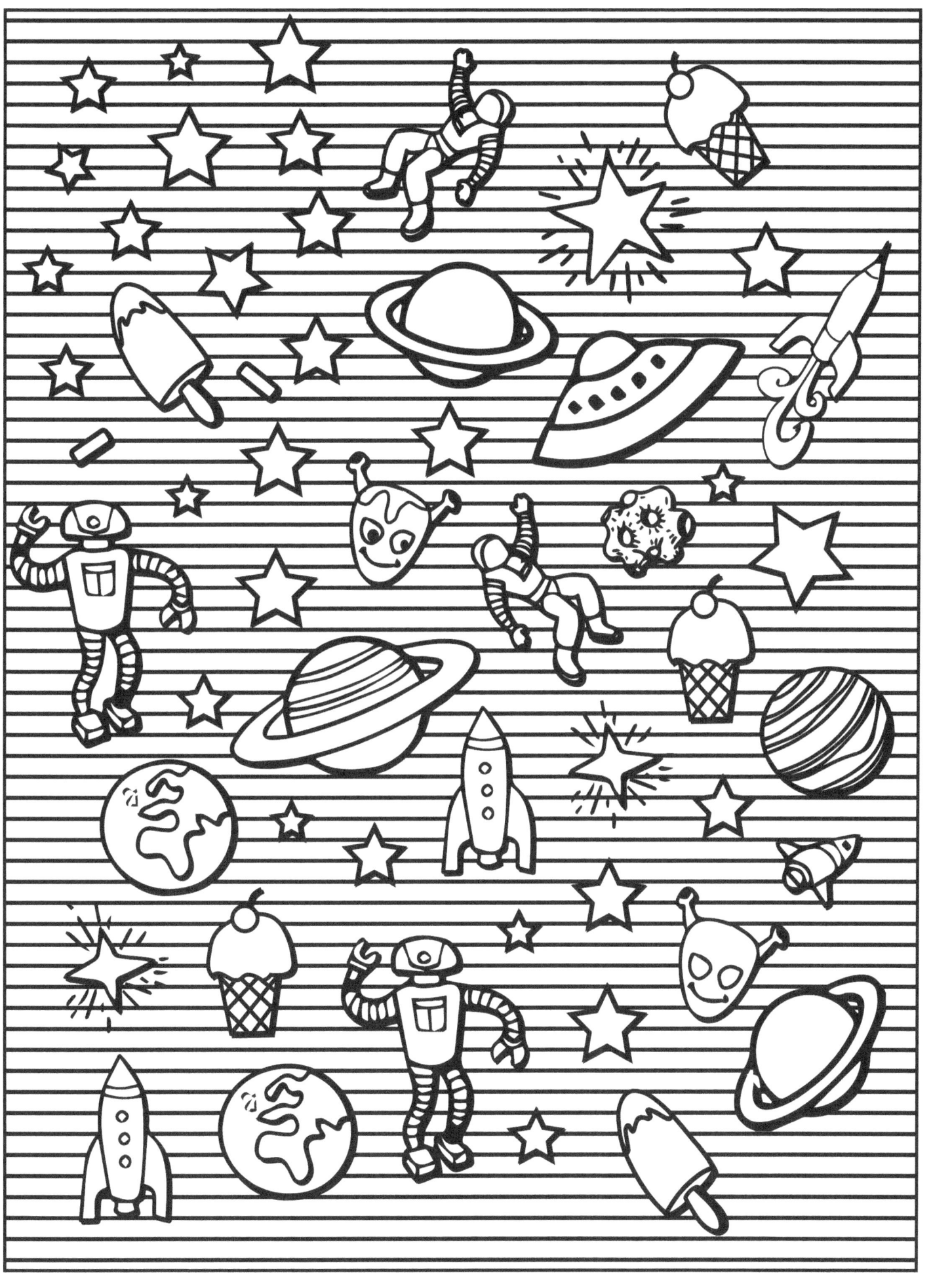

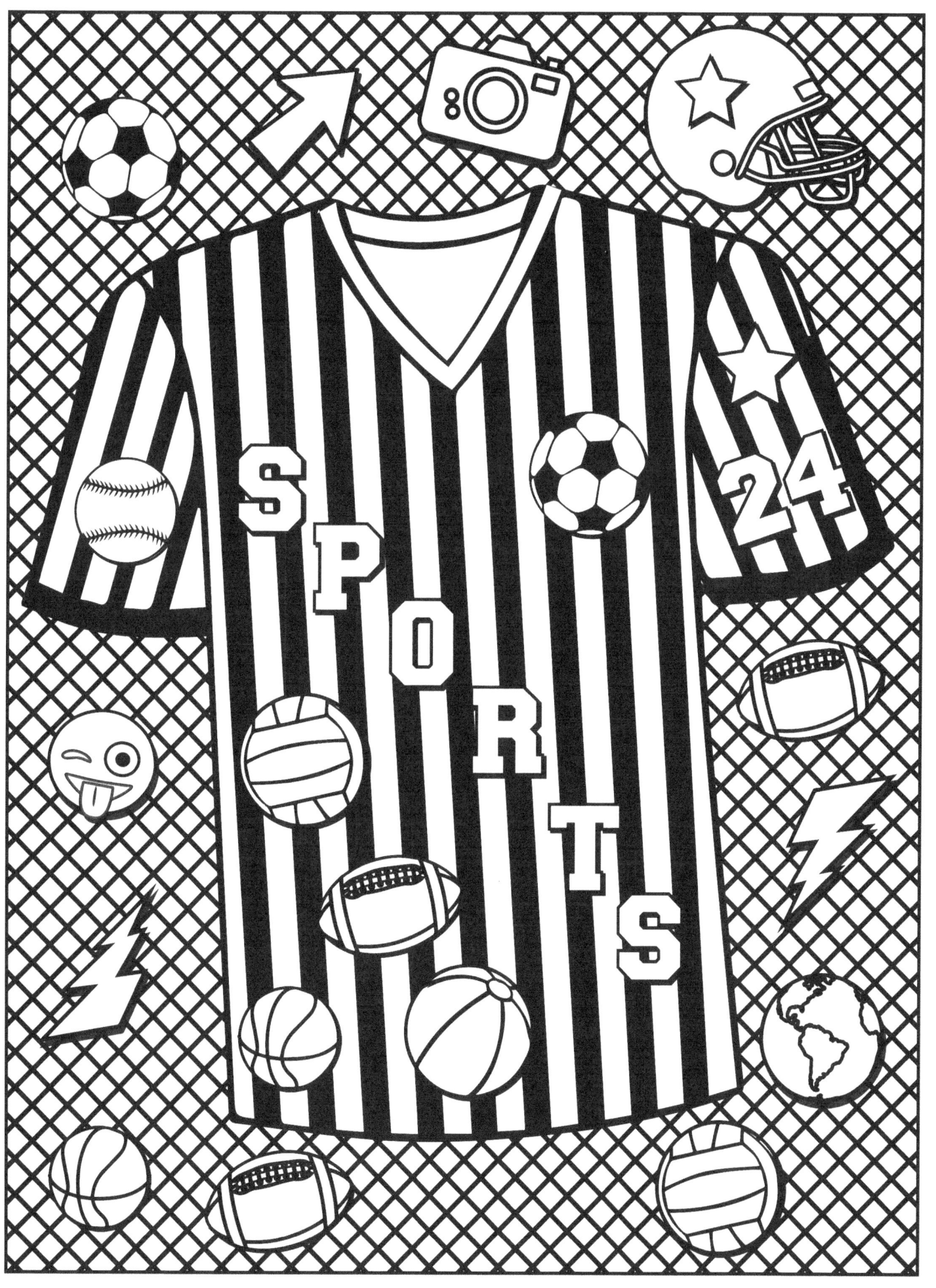

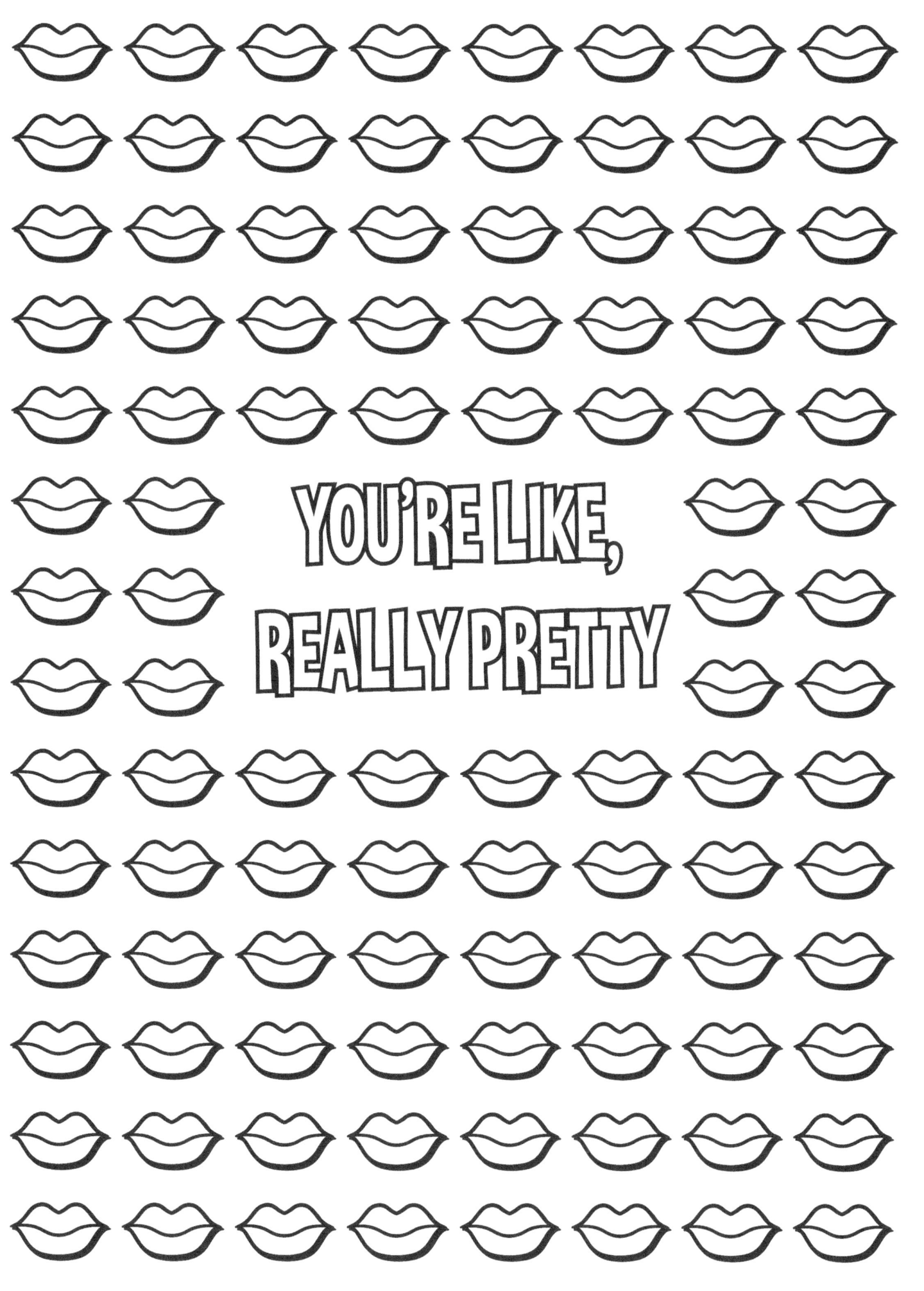

Photobooth Fun! Draw your favorite things in the photo spaces or glue pictures inside them!

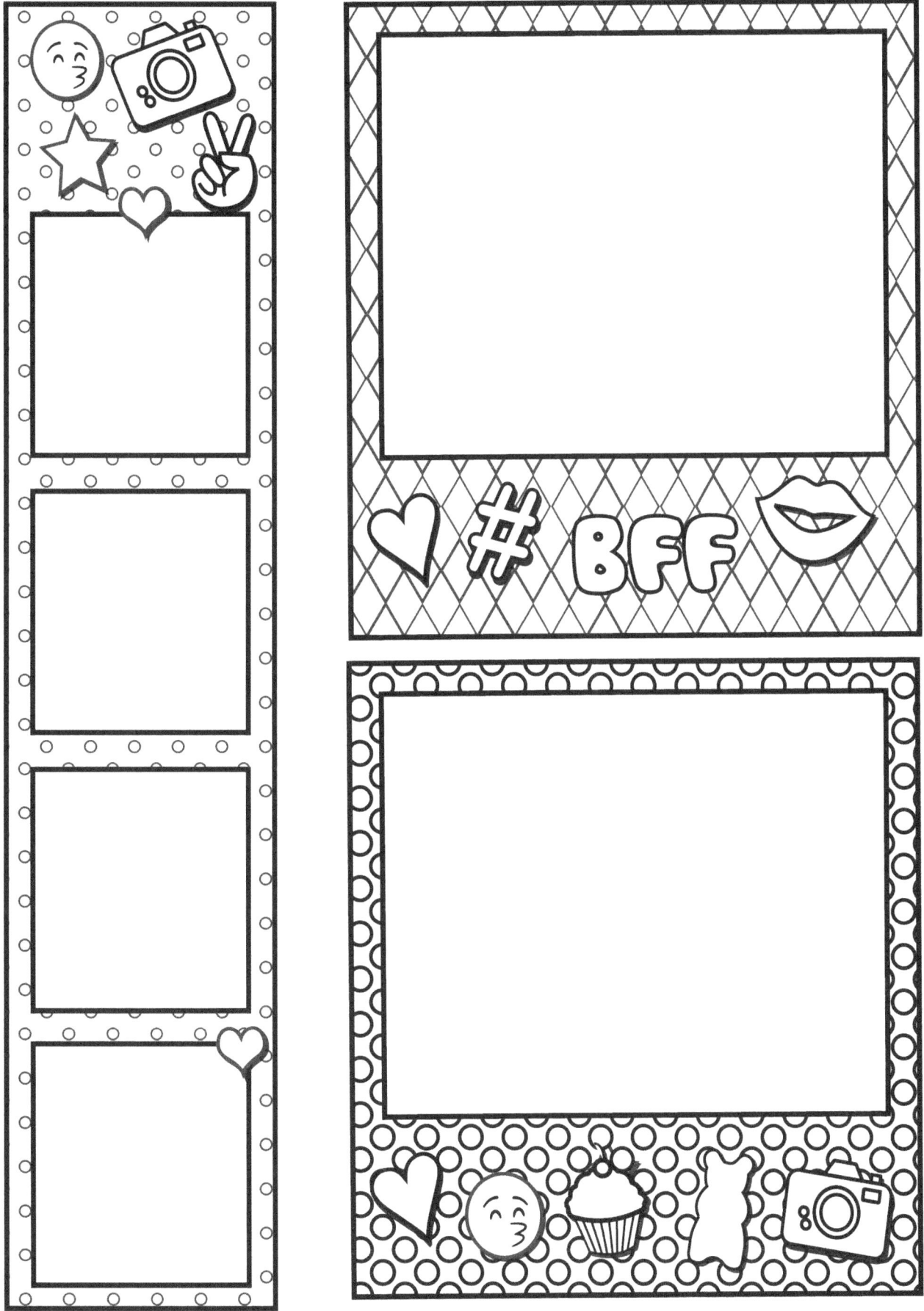

Then cut them out and tape them to your wall, notebook, or give them to a friend!

www.ingramcontent.com/pod-product-compliance
Lightning Source LLC
Chambersburg PA
CBHW080606190526
45169CB00007B/2905